All you need is ART
Taller creativo de 3 a 90 años

© 2022 Instituto Monsa de ediciones.

First edition in April 2022 by Monsa Publications,
Gravina 43 (08930) Sant Adrià de Besós.
Barcelona (Spain) T +34 93 381 00 93
www.monsa.com monsa@monsa.com

Editor and Project Director Anna Minguet
Design, layout, text editing Eva Minguet
(Monsa Publications)
Translation Somostraductores.com
Printing Cachiman Gráfic

Shop online: www.monsashop.com
Follow us! Instagram: @monsapublications

ISBN: 978-84-17557-48-5
D.L. B 6008-2022
April 2022

Image credits: goodstudio©123rf, knstart©123rf, nadinevereska©123rf,
oksanastepova©123rf, solodkayamari©123rf.

Creativity is a truly valuable skill, not only for artistic endeavors but for any aspect of life. This workshop is designed so that through graphic-plastic expression techniques, crafts and activities, you can stimulate and develop your inner artist, and at the same time allow children to experiment with their creative side where they can free their imagination. Based on the premise that creative thinking is perhaps one of our best resources since it generates many intellectual, emotional and affective benefits.

La creatividad es una capacidad realmente valiosa, no sólo para el ámbito artístico, sino para cualquier aspecto de la vida. Este taller está diseñado para que a partir de técnicas de expresión gráfico-plásticas, manualidades y actividades, puedas estimular y desarrollar tu artista interior, y a su vez permitir a los niños experimentar con su lado más creativo donde liberar su imaginación. Partiendo de la base de que el pensamiento creativo es el mejor de los recursos, ya que genera gran cantidad de beneficios, tanto intelectuales como emocionales y afectivos.

CONTENTS

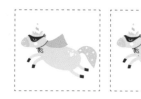

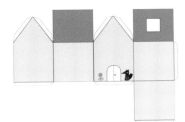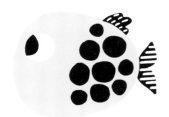

THE POWER OF LETTERING

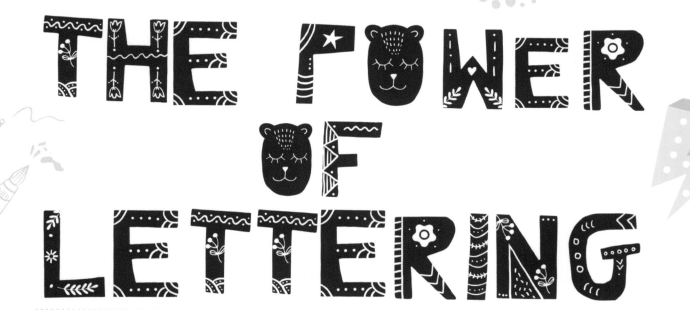

Lettering is the art of drawing beautiful letters, inspired by traditional calligraphy. Unique letters are created for the design or project you need, with the final composition being the actual artistic result.
Below you will find different examples of lettering to inspire your creations.

El lettering es el arte de dibujar letras bonitas, inspirado por las caligrafías existentes, se elaboran letras únicas para el diseño o proyecto que se necesite, siendo la composición final el verdadero resultado artístico.
A continuación encontrareis diferentes ejemplos de lettering, para inspirar vuestras creaciones.

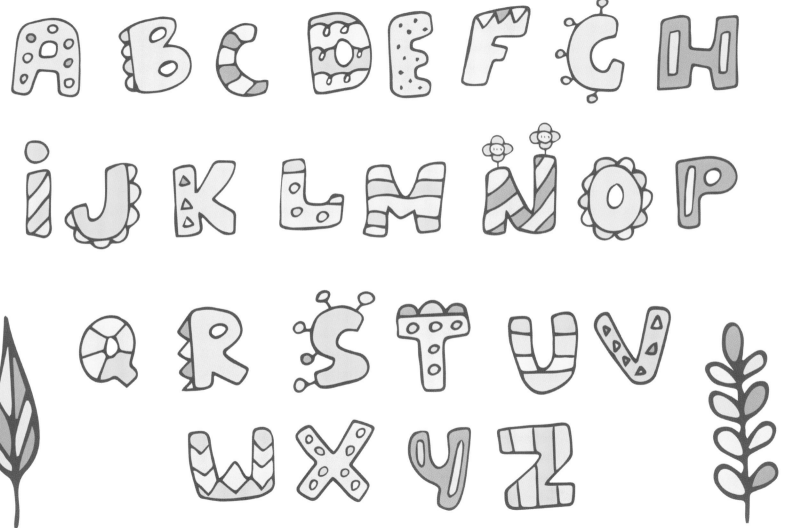

A B C D E F G H
I J K L M N O P Q
R S T U V W X Y Z
1 2 3 4 5 6 7 8 0

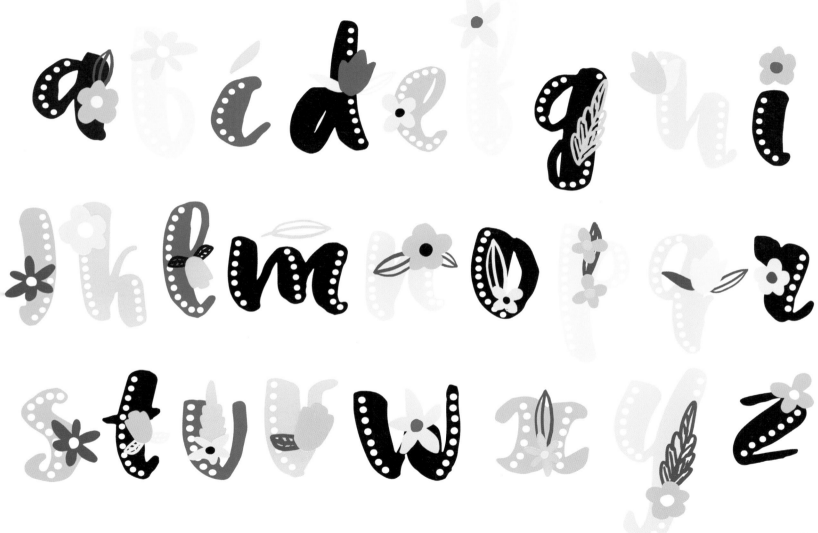

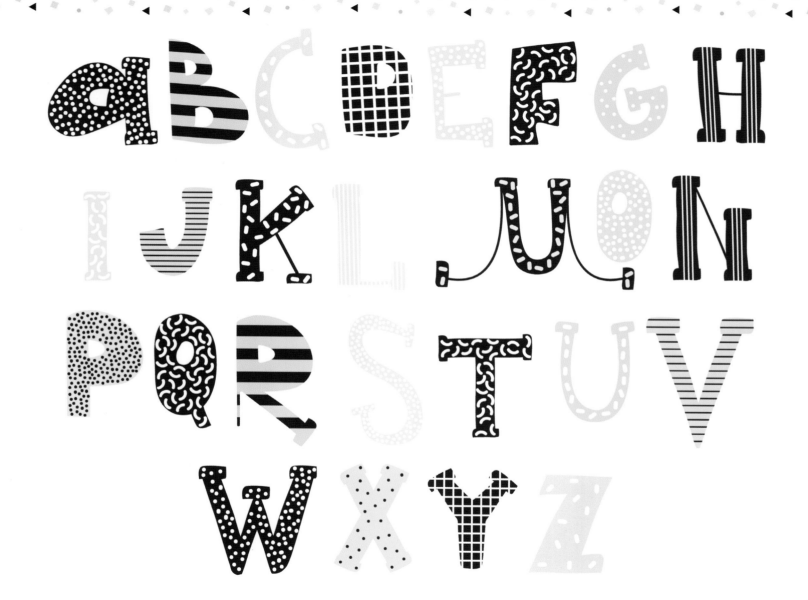

A B C D E F G

H I J K L M N

O P Q R S T

U V W X Y Z

A B C D E F G H I J

K L M N O P Q R

S T U V W X Y Z

ABCDEFGHIJ

KLMNOPQR

STUVWXYZ

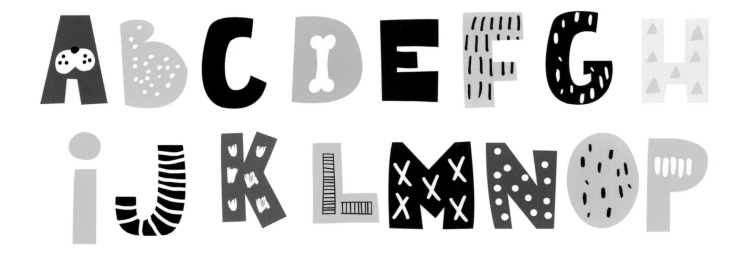

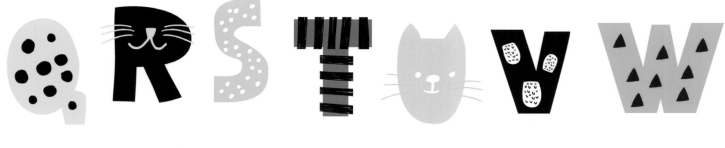

A B C D E F G H I

J K L M N O P Q

R S T U V W

X Y Z

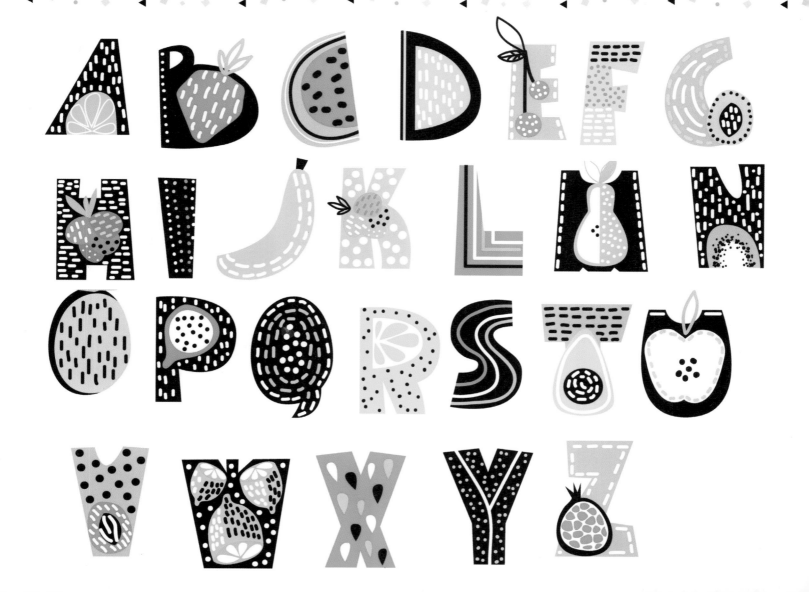

CREATE YOUR OWN LETTERING

E

..

..

..

..

..

..

..

..

G

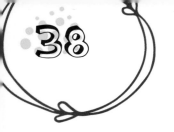

DECOR GARLAND

The combination of colors, sizes and textures helps to personalize your work.
Decorate your lettering compositions or notebooks with different details.
Find inspiration with the examples on the following pages.

La combinación de colores, tamaños y texturas ayudan a personalizar tus trabajos.
Decora tus composiciones de lettering o tus cuadernos con diferentes detalles.
Encuentra la inspiración con los trabajos de las siguientes páginas.

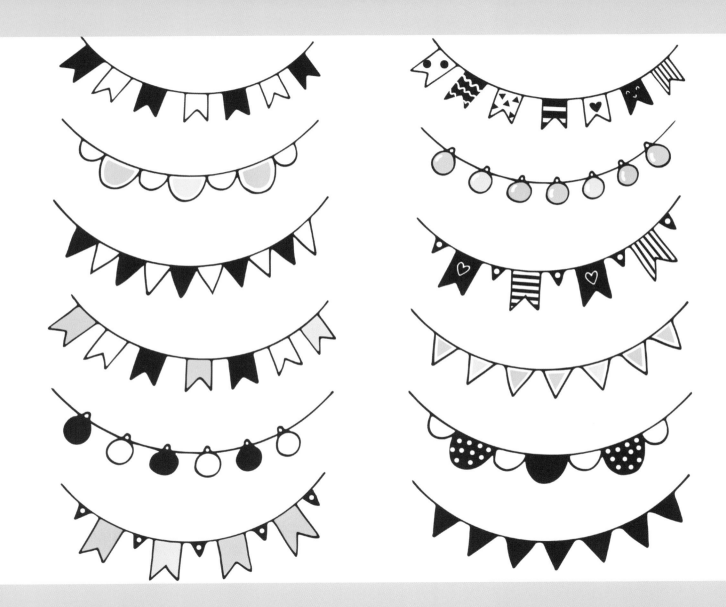

MIDORI NOTEBOOK

What are Midori notebooks?
They are DIY notebooks used for jotting down ideas, drawings, practicing lettering, or placing photographs.

1. Cut the pages of the notebook and fold them along the dotted line.
2. Once all our sheets are folded, we can staple them together.
3. Once stapled, we can trim them with a cutter so that they are all the same size.

¿Qué son los cuadernos Midori?
Es un cuaderno DIY, para anotar ideas, para dibujar, para practicar lettering o para colocar fotografías.

1. Corta las hojas del cuaderno y doblalas por la línea discontinua.
2. Una vez dobladas todas nuestras hojas del cuaderno, podemos grapar las hojas.
3. Una vez grapado podemos pulir con un cuter para que queden todas exactamente de la misma medida.

About the Author

· ·

· ·

· ·

· ·

· ·

Once upon a time...

The End

About the Author

..................................

..................................

..................................

..................................

..................................

..................................

Once upon a time...

..

..

..

..

..

..

..

..

..

..

..

..

..

..

..

..

..

..

..

..

..

..

The End

About the Author

..
..
..
..
..
..

Once upon a time...

· ·

· ·

· ·

· ·

· ·

· ·

· ·

· ·

· ·

· ·

· ·

The End

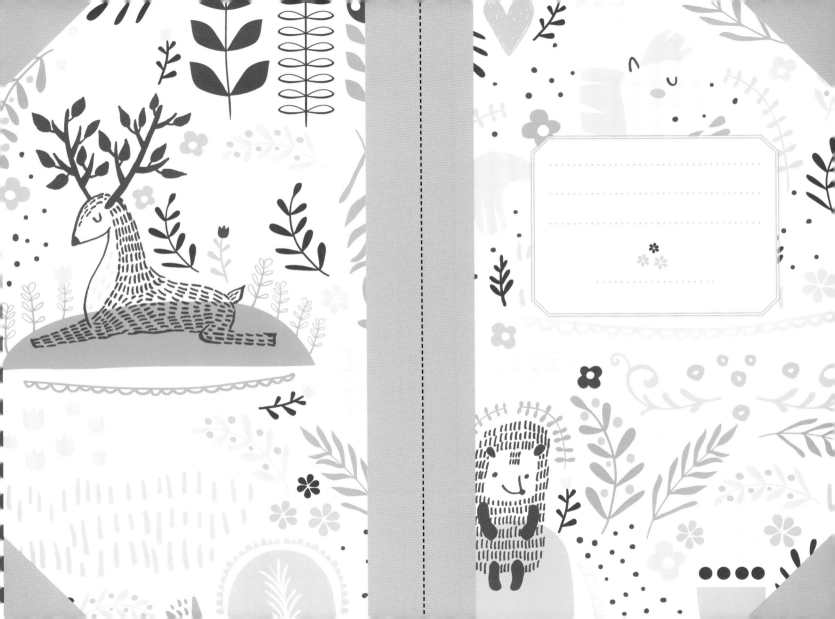

About the Author

. .

. .

. .

. .

. .

. .

Once upon a time...

The End

EXPLORE YOUR CREATIVITY

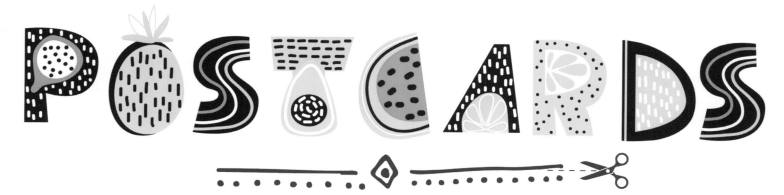

POSTCARDS

Cut out and personalize these fun postcards! Use them as invitations to an event, remind someone how important they are to you, or simply decorate your room with them.

¡Recorta y personaliza estas divertidas postales! Úsalas como invitaciones a un evento, para recordarle a alguien lo importante que es para ti, o simplemente decora con ellas tu habitación.

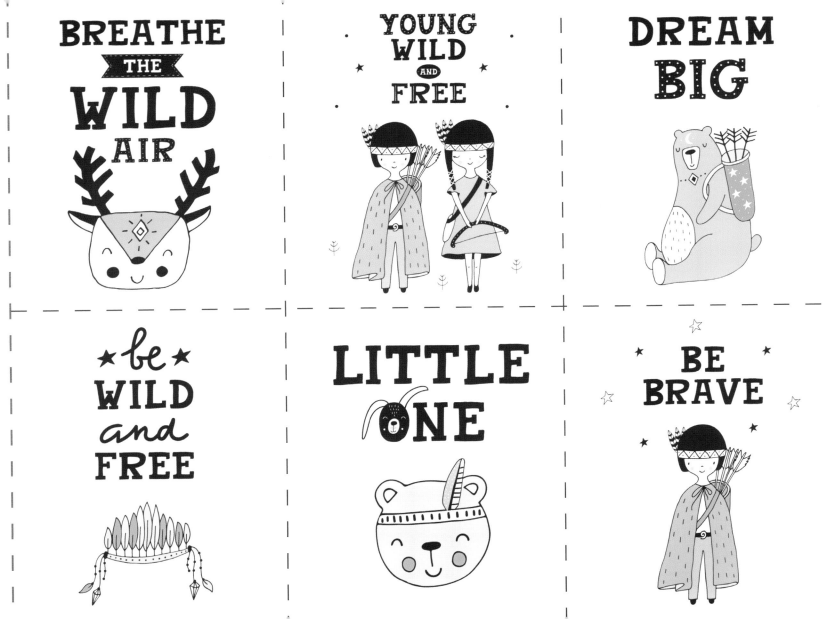

FREE

BE
BRAVE

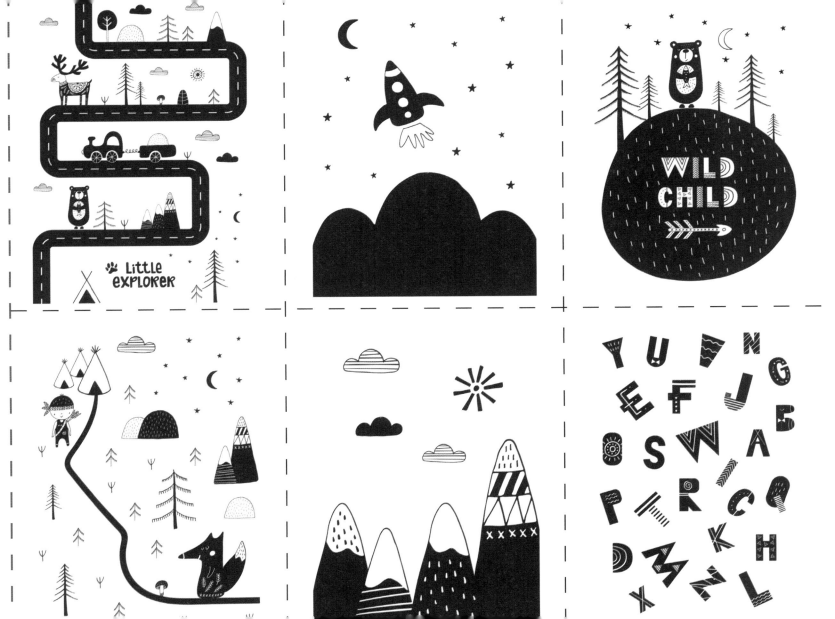

DreaM
BIG

LOVE FLOWERS

ROO
aRr

Big dreamer

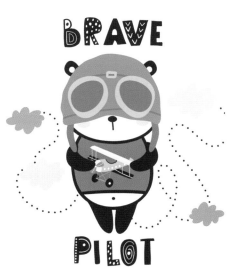

BRAVE

PILOT

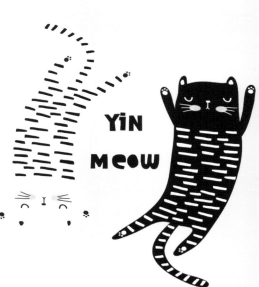

YiN
meow

LOVE

Big dreamer

90

PLAY

Now it's time to have fun with games, construction projects, and activities with paper. You can have your own aquarium, build a house or a doll, color, and exercise your memory.
Let's play!

Ahora toca divertirnos con juegos, construcciones y actividades con papel. Podrás tener tu propio acuario, montar una casa o un muñeco, colorear, y ejercitar tu memoria.
¡Vamos a jugar!

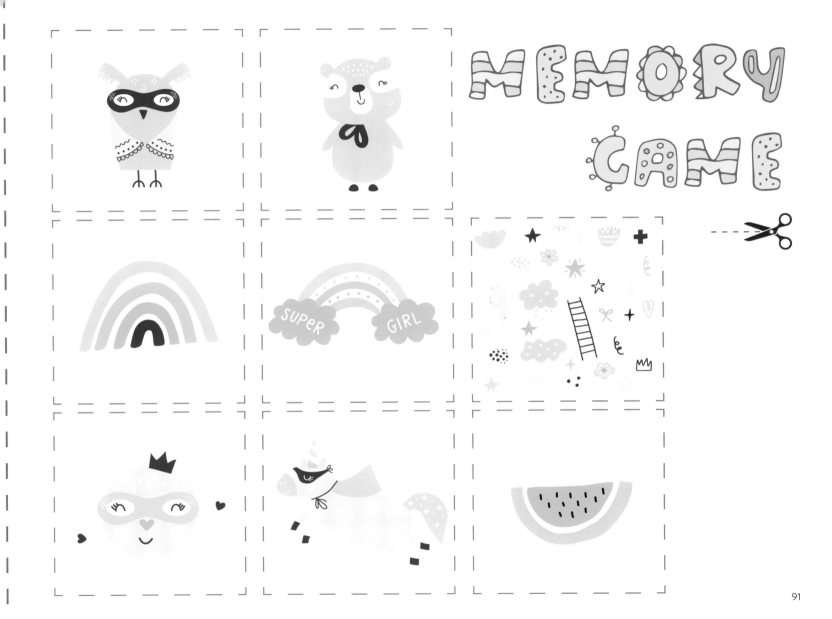

MEMORY GAME

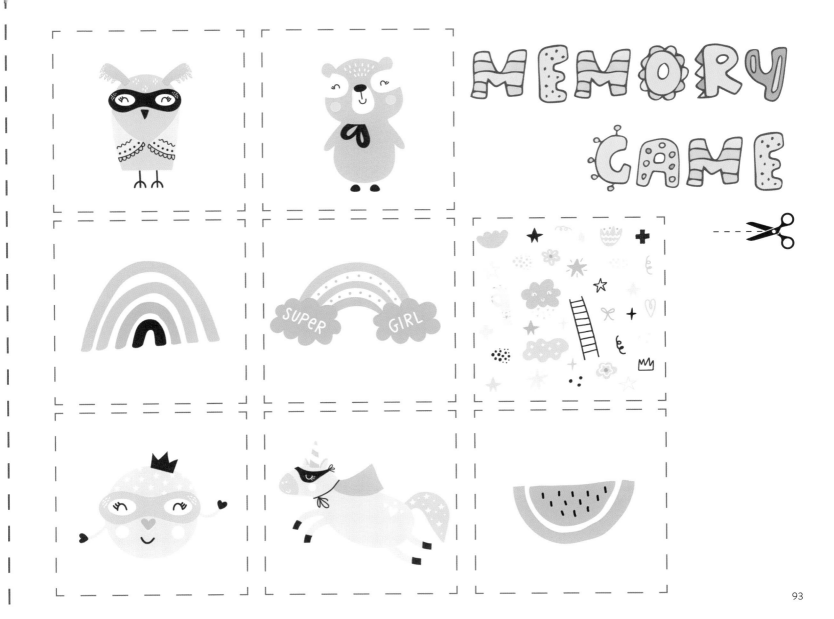

MEMORY GAME

SUPER GIRL

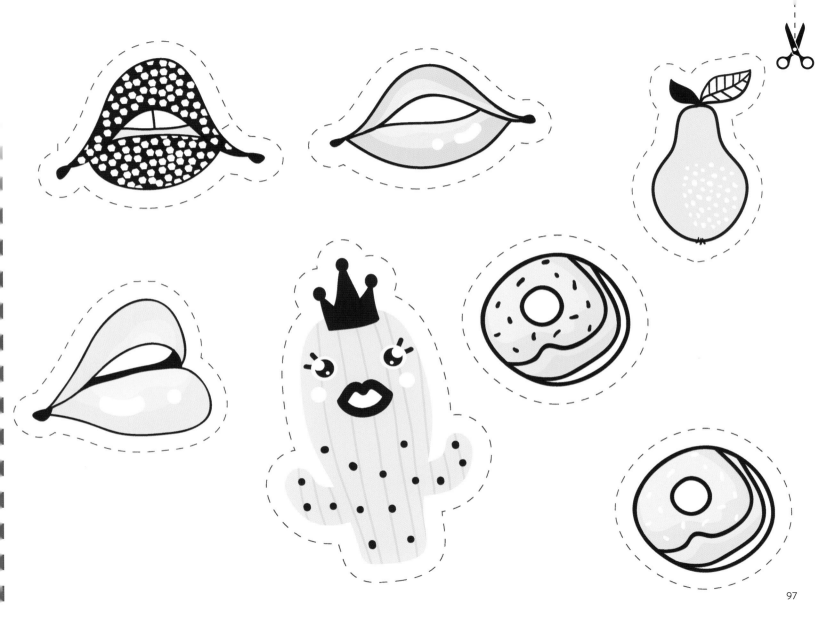

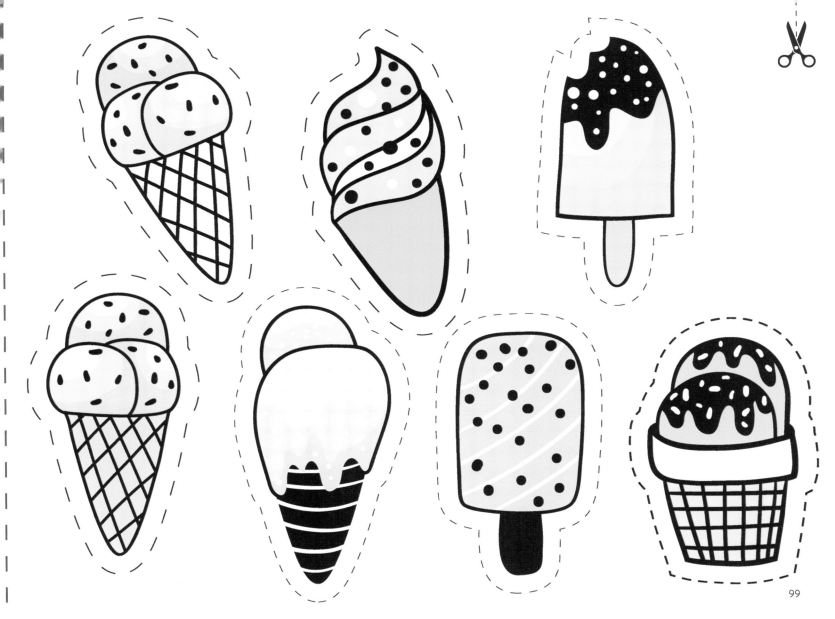

99

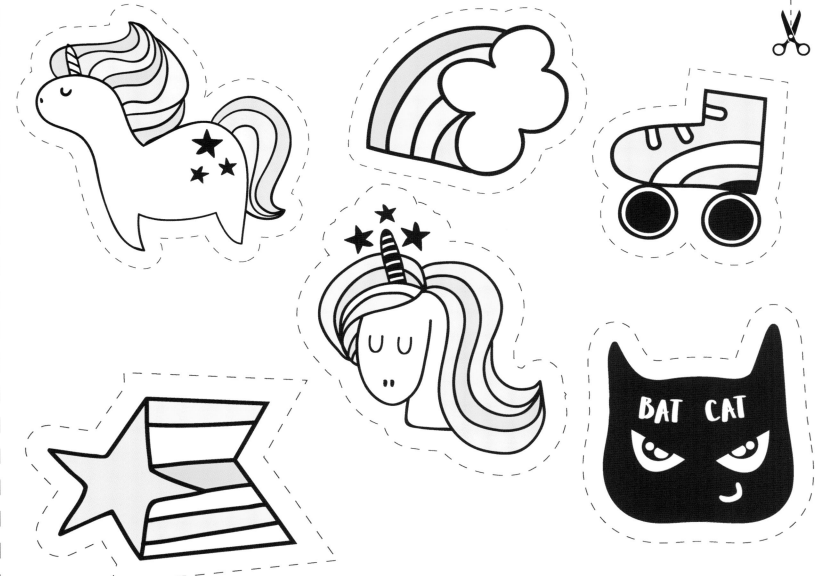

PAPER HOUSES

1. Cut along solid lines.
2. Fold along dashed lines.
3. Cut out black sections.

1. Cortar por las líneas continuas.
2. Doblar por las líneas discontinuas.
3. Cortar las secciones negras.

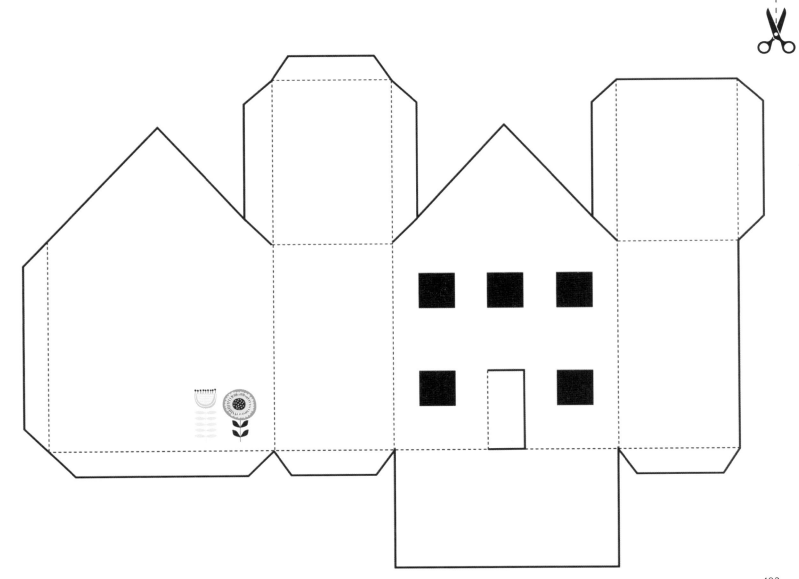

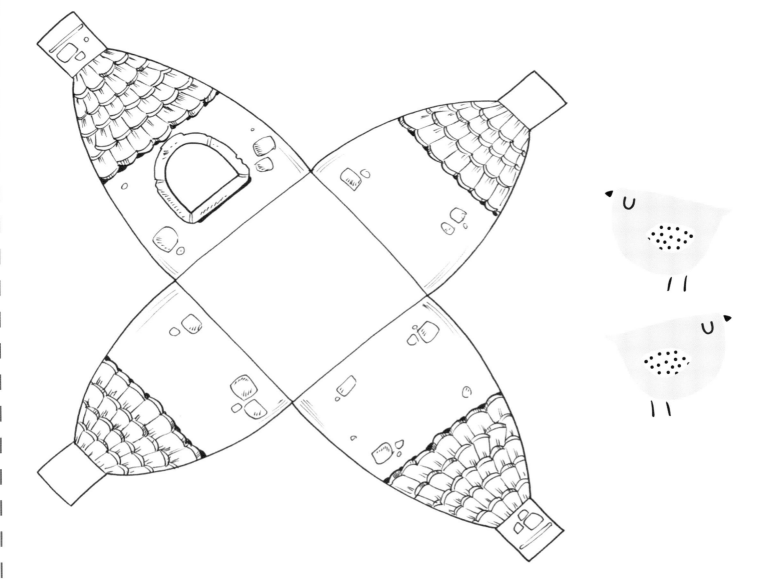

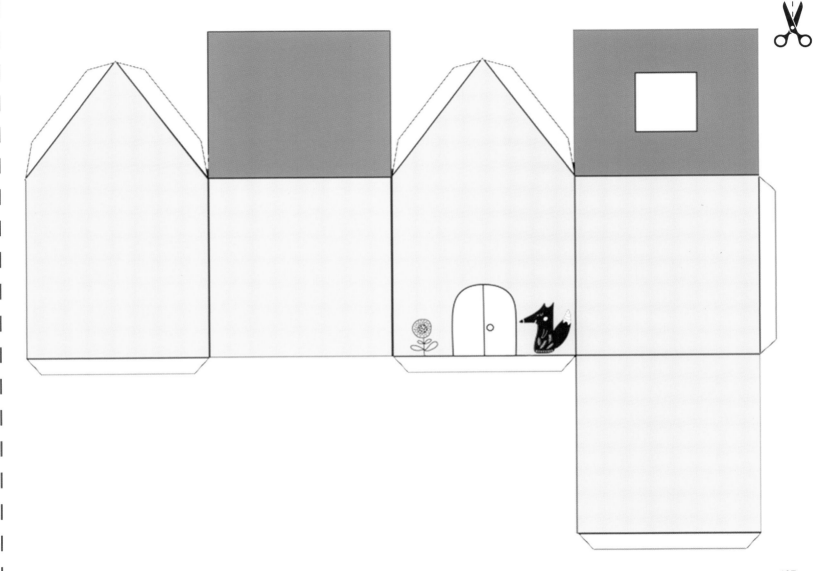

HOME SWEET HOME

ORICAMI

1

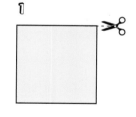

2

3

4

5

x4

6

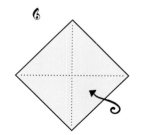

7

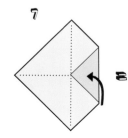

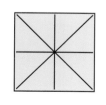

8

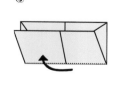

9

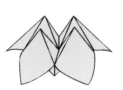

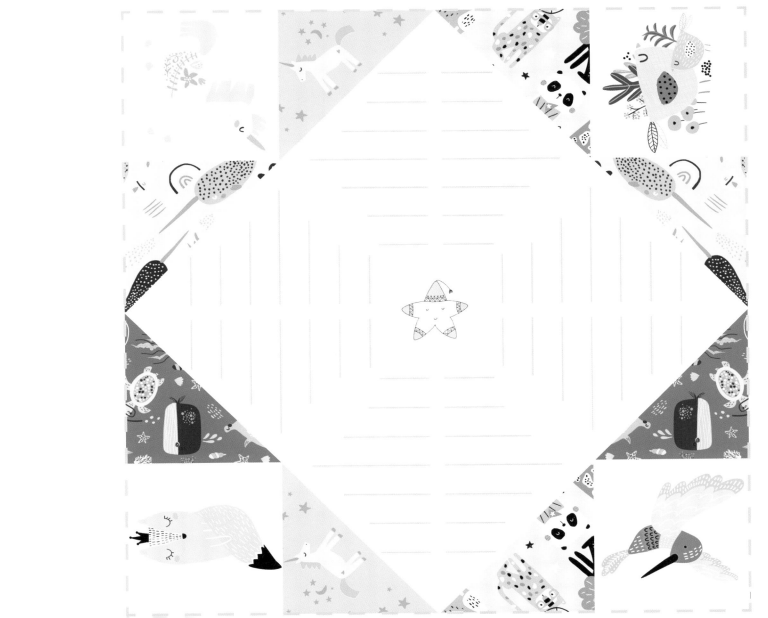

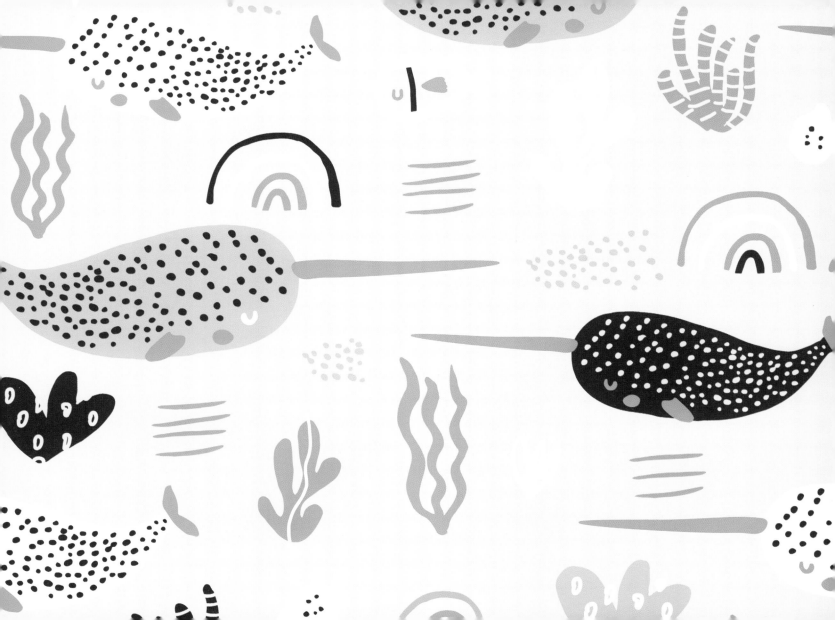

Fun Activity

1. Color and cut the picture.
2. Paste the pictures inside the fishbowl.

1. *Colorea y recorta las imágenes.*
2. *Pega las imágenes dentro de la pecera.*

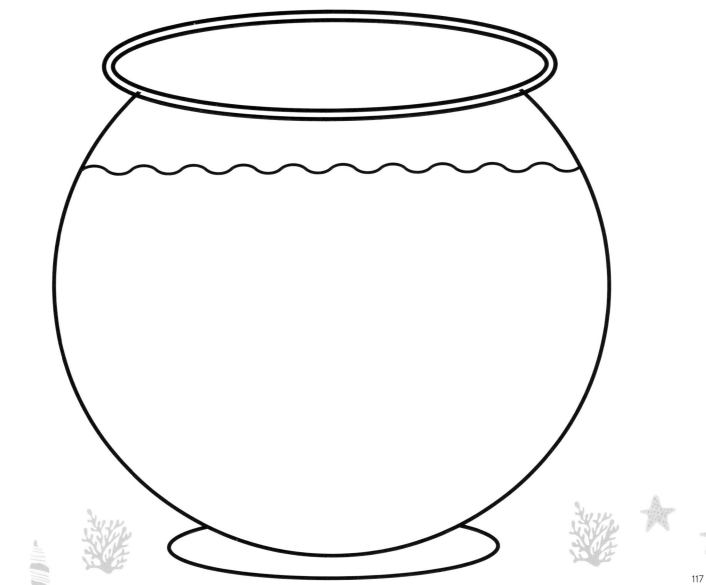

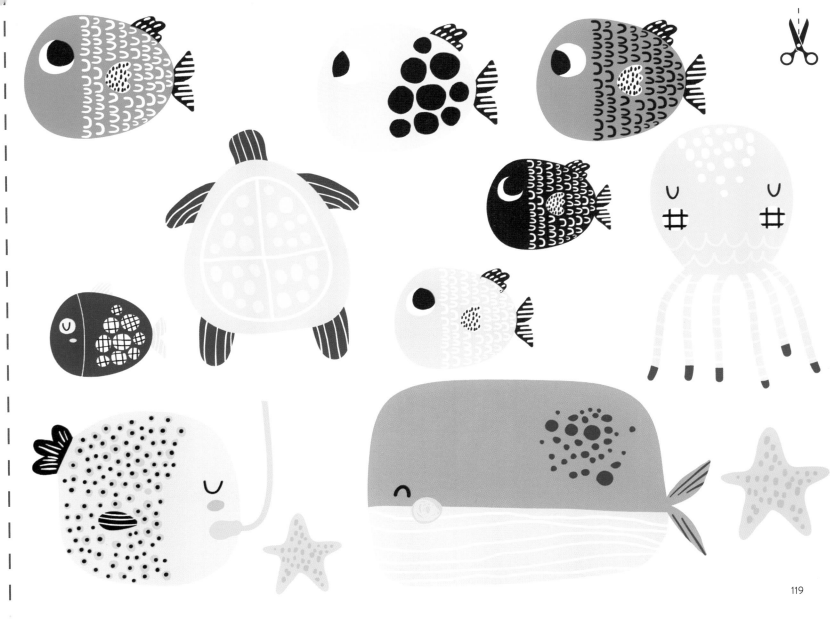

119

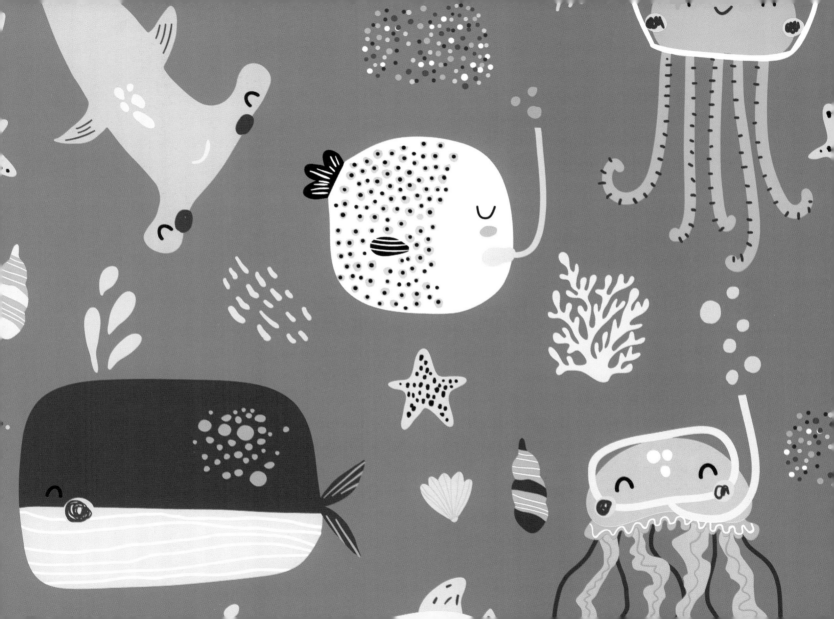

PAPER TOYS

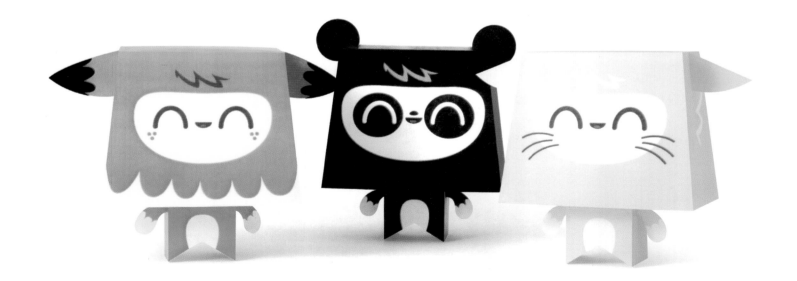

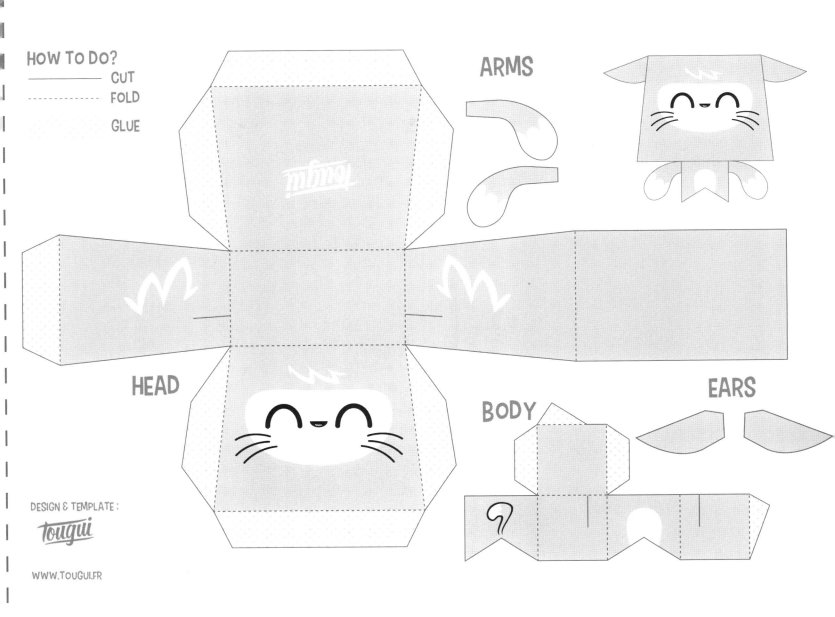

HOW TO DO?

———————— CUT

- - - - - - - - FOLD

GLUE

ARMS

HEAD

BODY

EARS

DESIGN & TEMPLATE :

tougui

WWW.TOUGUI.FR

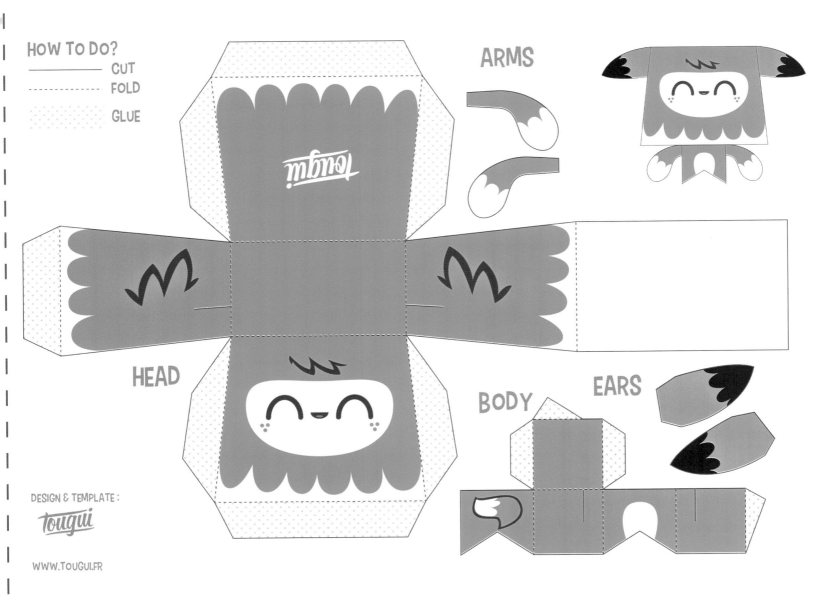

HOW TO DO?

———————— CUT

- - - - - - - - FOLD

············· GLUE

ARMS

HEAD

BODY EARS

DESIGN & TEMPLATE :

tougui

WWW.TOUGUI.FR

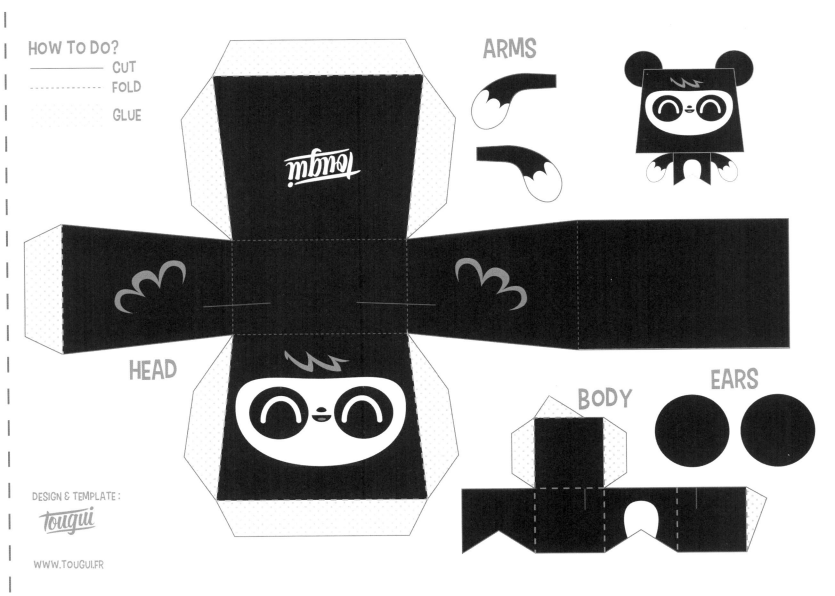

HOW TO DO?

———— CUT

------------- FOLD

GLUE

ARMS

HEAD

BODY

EARS

DESIGN & TEMPLATE :

tougui

WWW.TOUGUI.FR

THE BEST ARTWORK IS YOURS

130

PUPPETS FOR YOUR FINGERS

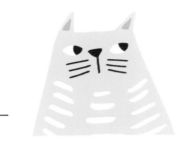

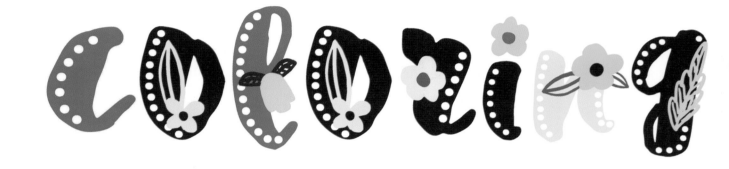

Fun Activity

Use your favorite colors to bring the following images by illustrator Meni Tzima to life.

Usa tus colores favoritos para dar vida a las siguientes imagenes de la ilustradora Meni Tzima.

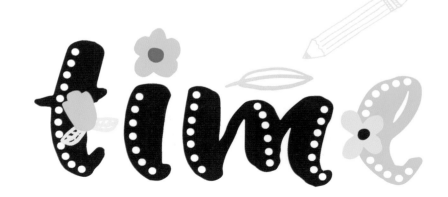

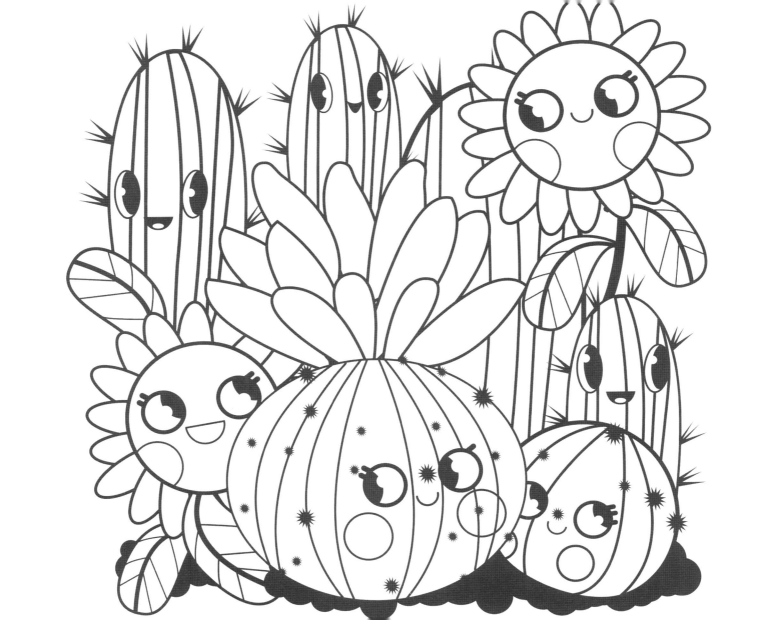

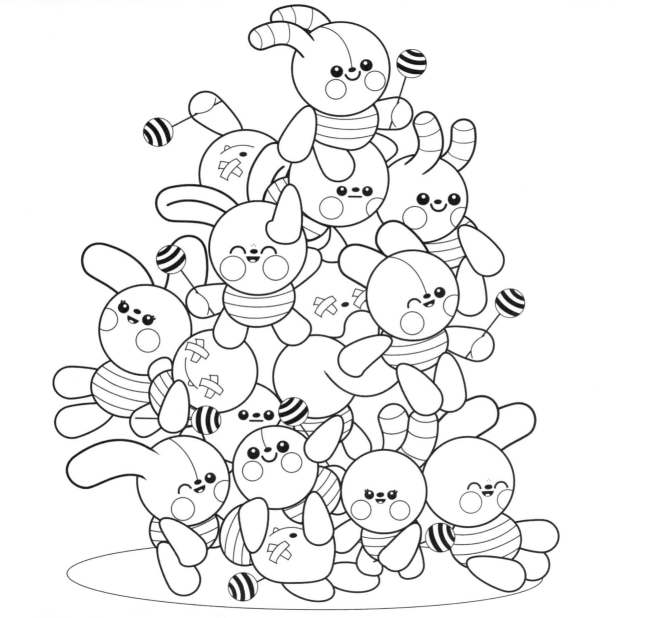

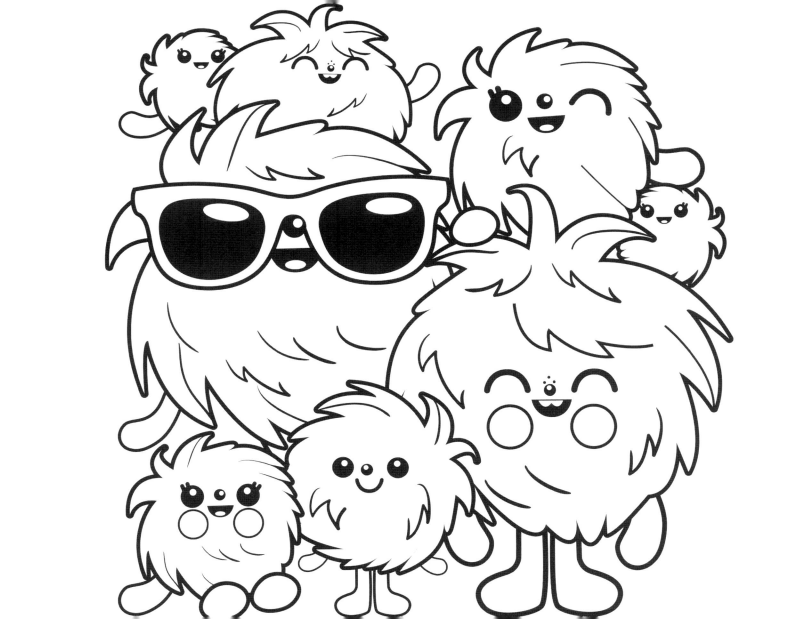

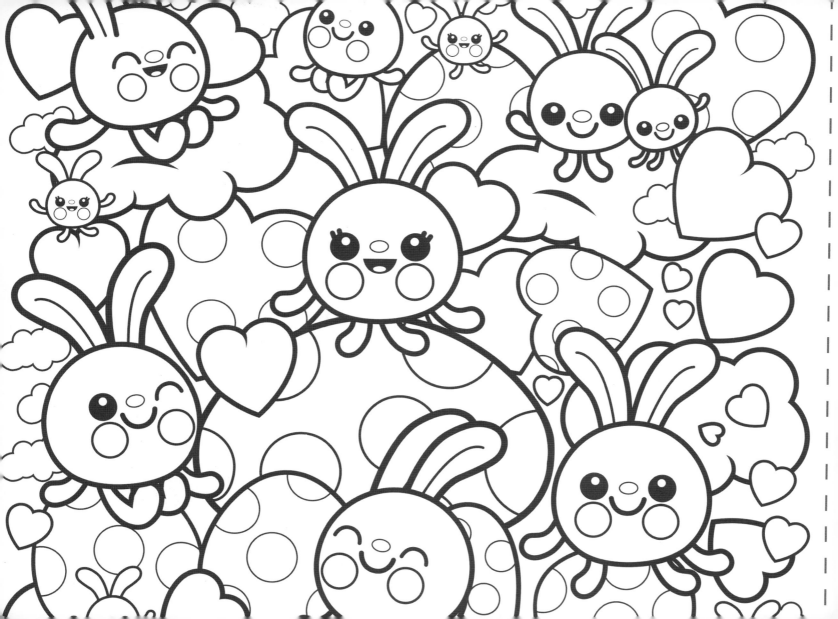

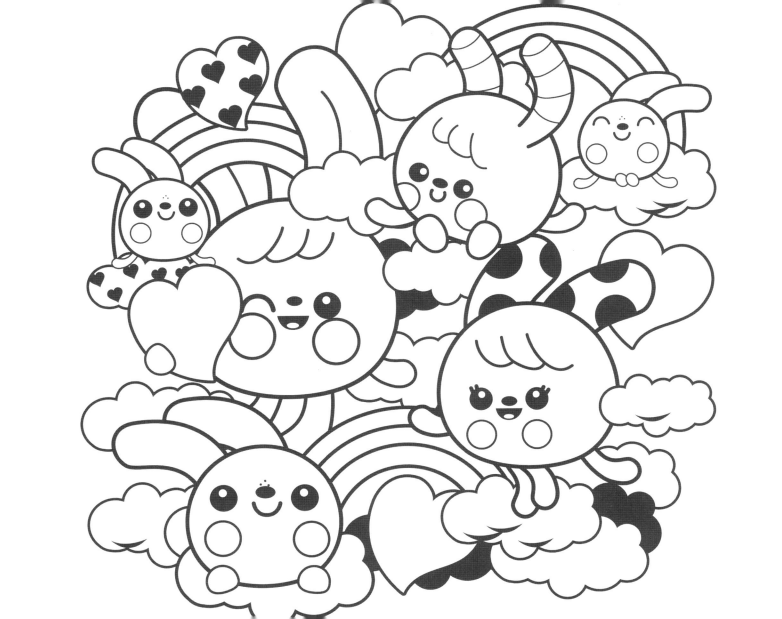

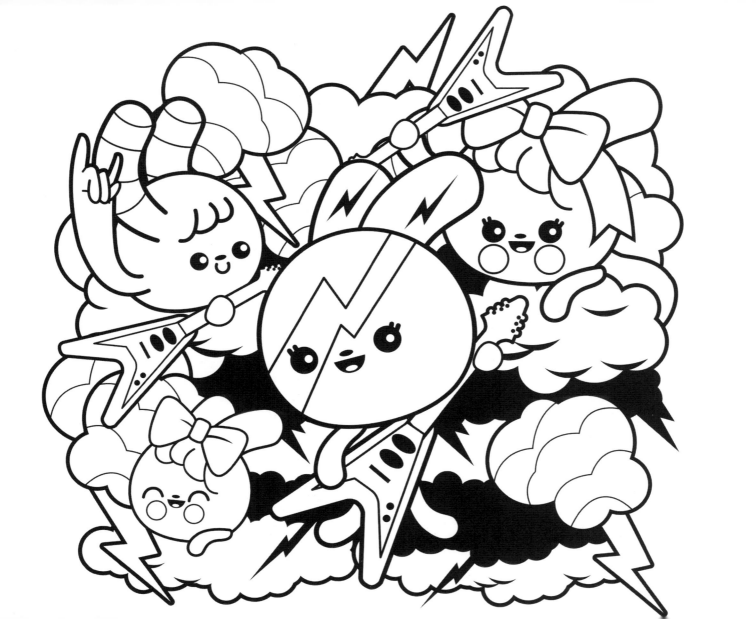

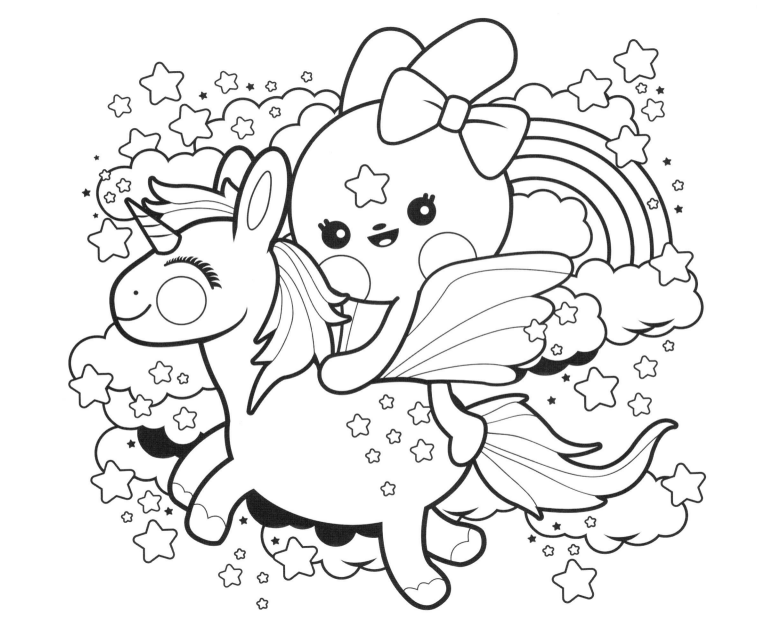